HAIR ICONS

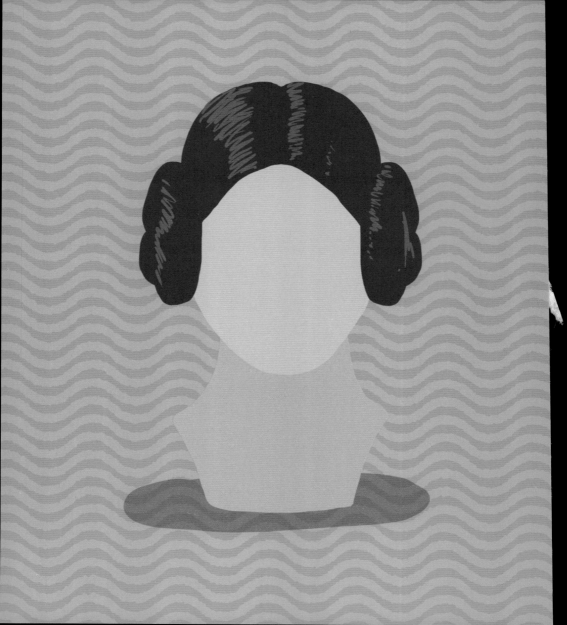

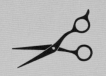

HAIR ICONS

POP CULTURE'S MOST MEMORABLE HAIRDOS

LUKE TRIBE

Smith Street Books

CONTENTS

INTRODUCTION

I've always had a tumultuous love affair with my hair. I'm what professionals in the hair industry might describe as: "desperate and impressionable". Yet, perhaps because my grandfather was a barber, I've long felt that "hair" is in my roots. (Literally and figuratively.)

Growing up in the 80s meant that big hair was always going to play a large role in my life. Across our TV and film screens, there was just so much voluminous hair. My influences in those formative years were gloriously camp cartoons, like *Jem and the Holograms*, and iconic women like Dolly Parton, Goldie Hawn, and Tina Turner. For these heroines of hair there was one golden rule: bigger is always better. I took this as gospel and throughout the years have cycled through many bold hairstyles of my own.

In the mid-90s, at the peak of my imagined teenage cool, I rocked a severe undercut, which parted in the middle and billowed out on either side. (Pictured page right, in all its floppy glory.) Was I trying to emulate Backstreet Boys' Nick Carter? Yes. Was it working? Probably not, but I was really feeling myself.

Since those middle-parted days, I've bleached my hair countless times. I've coloured it black and blond. I've straightened it, highlighted it, and – yes – dyed it bright red. I've had undercuts, emo fringes, aggressive mullets, and just short back 'n' sides. You name a hairstyle or a colour – I've had it.

Then, in the early 2000s, as a timid gay man in my twenties, I found myself working as a hairdresser's apprentice. One day, while working in the salon, I was struck by a great hair epiphany. "Maybe," I thought, "I should get hair extensions, but just for my fringe." (I repeat: early 2000s.) With my faux fringe came a newfound confidence. I even entered a dance competition at my favourite gay bar, flicking and whipping my fringe all the way to first place. I won a $20 bar tab and the drunken crowd's complete adoration. Neck pain aside, success never felt so good.

That was nearly two decades ago. Although I now make my living as an illustrator and designer, I never stopped obsessing over hair. So, in my free time, I began drawing my favourite hairdos in pop culture. What started as a creative pastime quickly took on a life of its own, culminating in this book. I hope it serves as a reminder that bigger is always better – to be bold in your hair choices, as in life.

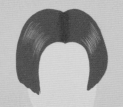

FILM & TV
CHARACTERS

PRINCESS LEIA

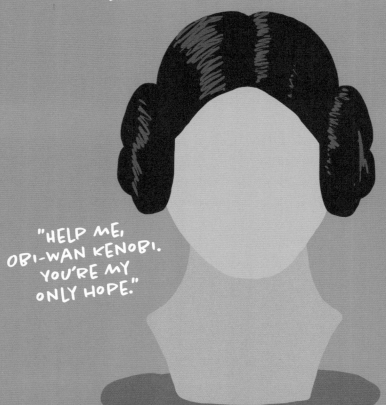

"HELP ME,
OBI-WAN KENOBI.
YOU'RE MY
ONLY HOPE."

Star Wars: Episode IV – A New Hope | 1977
Carrie Fischer, styled by Patricia McDermott

SARAH CONNOR

"WHY ME? WHY DOES IT WANT ME?"

The Terminator | 1984
Linda Hamilton, styled by Kyle Sweet and Peter Tothpal

JARETH

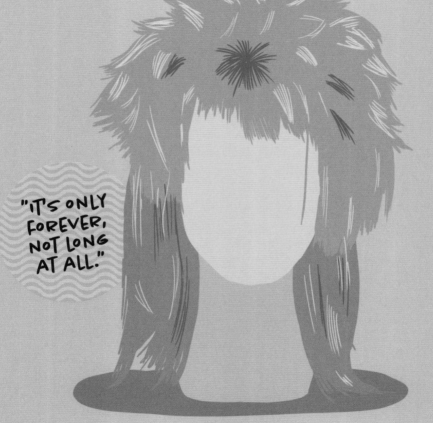

"IT'S ONLY FOREVER, NOT LONG AT ALL."

Labryinth | 1986
David Bowie, styled by Nick Dudman and Derry Haws

THE FRESH PRINCE

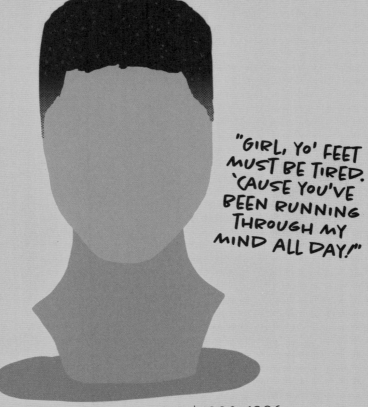

"GIRL, YO' FEET MUST BE TIRED. 'CAUSE YOU'VE BEEN RUNNING THROUGH MY MIND ALL DAY!"

The Fresh Prince of Bel-Air | 1990–1996
Will Smith, styled by Roddy Stayton

O-REN ISHII

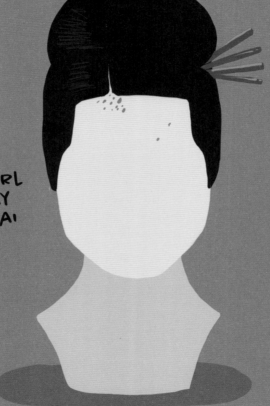

"SILLY CAUCASIAN GIRL LIKES TO PLAY WITH SAMURAI SWORDS."

Kill Bill: Volume 1 | 2003
Lucy Liu, styled by Noriko Watanabe

HOLLY GOLIGHTLY

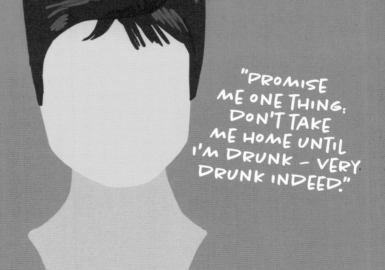

"PROMISE
ME ONE THING:
DON'T TAKE
ME HOME UNTIL
I'M DRUNK — VERY
DRUNK INDEED."

Breakfast at Tiffany's | 1961
Audrey Hepburn, styled by Nellie Manley

COUSIN ITT

"[HIGH-PITCHED GIBBERISH]"

Addams Family | 1964–1966
Felix Silia, styled by Charles Addams

THE MONSTER'S BRIDE

"IT'S A PERFECT NIGHT FOR MYSTERY AND HORROR. THE AIR ITSELF IS FILLED WITH MONSTERS."

Bride of Frankenstein | 1935
Esla Lanchester, styled by Irma Kusely

DOROTHY GALE

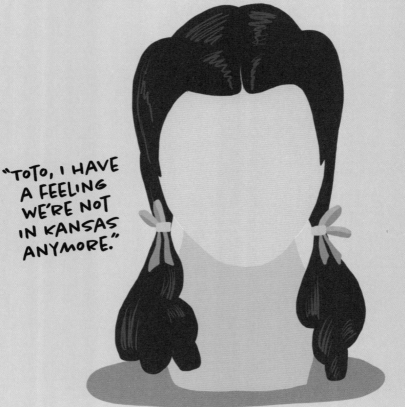

"TOTO, I HAVE A FEELING WE'RE NOT IN KANSAS ANYMORE."

The Wizard of Oz | 1939
Judy Garland, styled Sydney Guilaroff

SALLY BOWLES

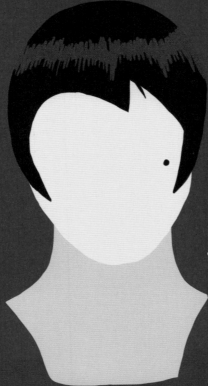

"I'M GOING TO BE A GREAT FILM STAR! THAT IS, IF BOOZE AND SEX DON'T GET ME FIRST."

Cabaret | 1972
Liza Minnelli, styled by Gus Le Pre

MARY JENSEN

"WHO NEEDS HIM? I'VE GOT A VIBRATOR!"

There's Something About Mary | 1998
Cameron Diaz, styled by Voni Hinkle

20

RACHEL GREEN

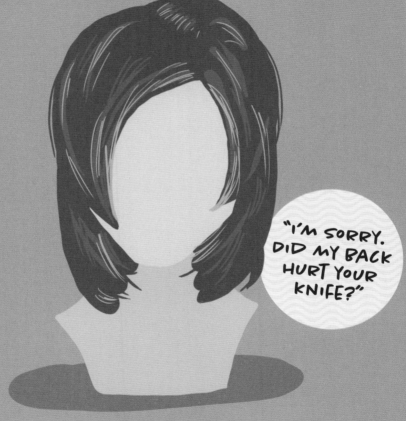

Friends | 1994–2004
Jennifer Aniston, styled by Chris McMillan

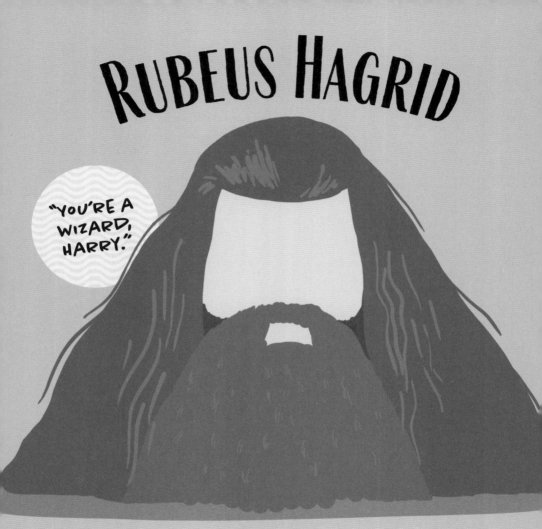

RUBEUS HAGRID

"YOU'RE A WIZARD, HARRY."

Harry Potter Series | 2001–2011
Robbie Coltrane, styled by Eithne Fennel

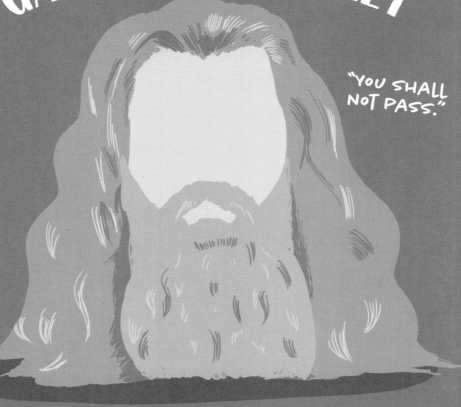

GANDALF THE GREY

"YOU SHALL NOT PASS."

The Lord of the Rings: The Fellowship of the Ring | 2001
Sir Ian McKellen, styled by Peter King

HEATHER DUKE

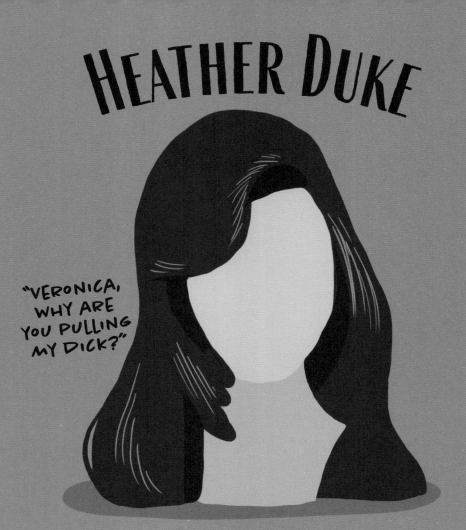

"VERONICA,
WHY ARE
YOU PULLING
MY DICK?"

Heathers | 1988
Shannen Doherty, styled by Scott Williams

BUFFY SUMMERS

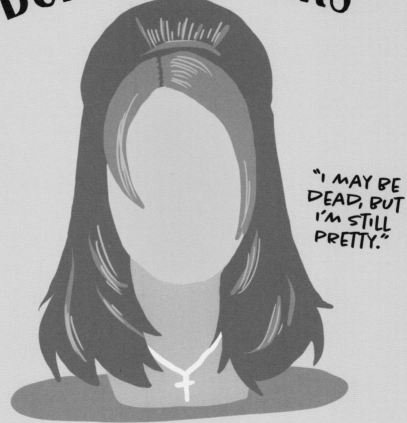

"I MAY BE DEAD, BUT I'M STILL PRETTY."

Buffy the Vampire Slayer | 1997–2003
Sarah Michelle Gellar, styled by Jeri Baker

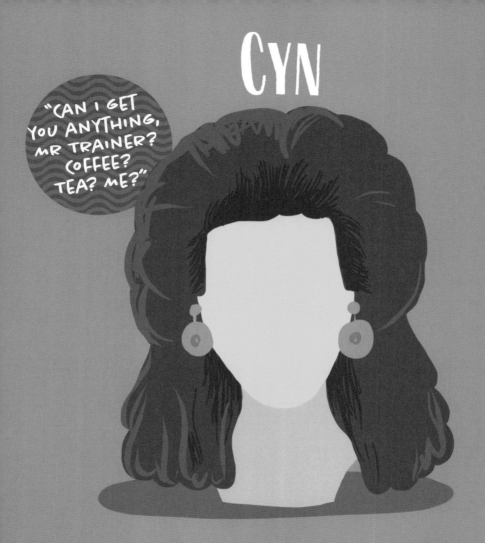

Working Girl | 1988
Joan Cusack, styled by Alan D'Angerio

MIRANDA HOBBES

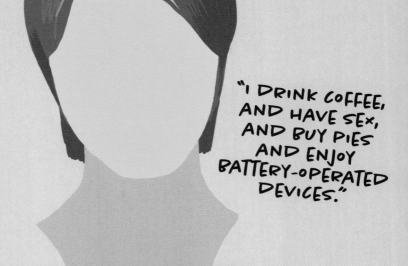

"I DRINK COFFEE, AND HAVE SEX, AND BUY PIES AND ENJOY BATTERY-OPERATED DEVICES."

Sex and the City | 1998–2004
Cynthia Nixon, styled by Donna Marie Fischetto

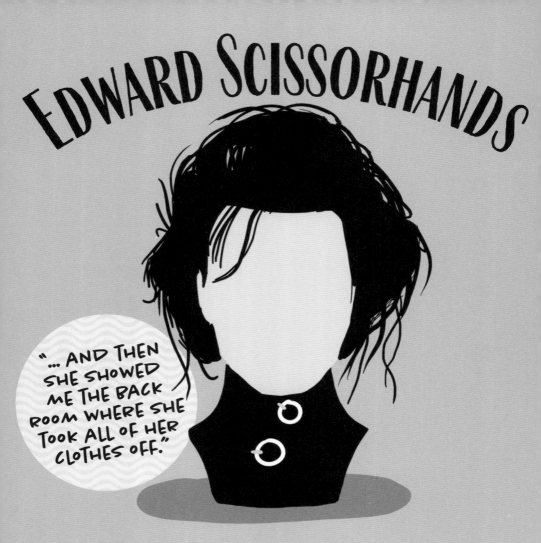

Edward Scissorhands | 1990
Johnny Depp, envisioned by Tim Burton

28

SASHA VELOUR

"LET'S GET INSPIRED BY ALL THIS BEAUTY, AND CHANGE THE MOTHERFUCKING WORLD."

RuPaul's Drag Race Season 9 | 2017
Dress by Florence D'Lee, stoned by House of Velour

RACHAEL

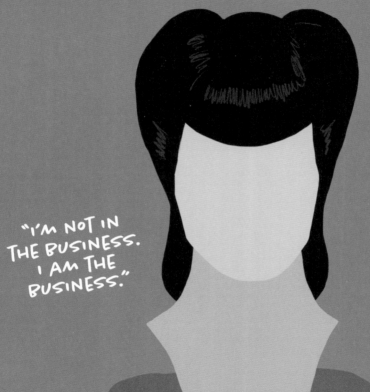

"I'M NOT IN THE BUSINESS. I AM THE BUSINESS."

Blade Runner | 1982
Sean Young, styled by Shirley Padgett

JANET WEISS

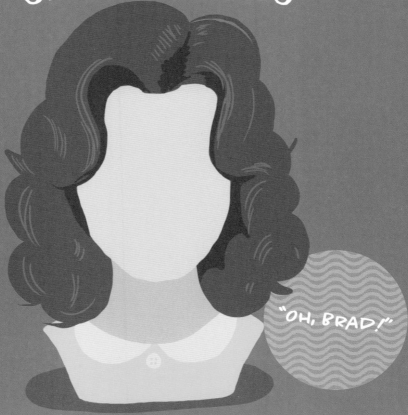

"OH, BRAD!"

The Rocky Horror Picture Show | 1975
Susan Sarandon, styled by Ramon Gow

KATE McCALLISTER

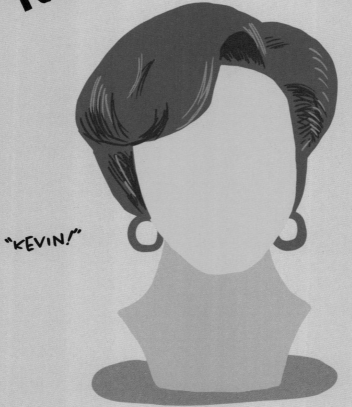

"KEVIN!"

Home Alone 2: Lost in New York | 1992
Catherine O'Hara, styled by Linda Rizzuto

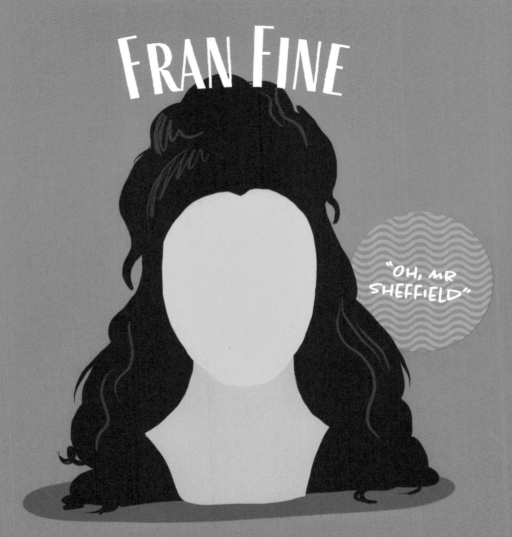

FRAN FINE

"OH, MR SHEFFIELD"

The Nanny | 1993–1999
Fran Drescher, styled by Faye Woods

FELICITY PORTER

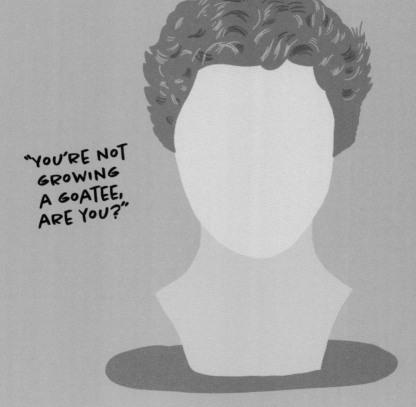

"YOU'RE NOT GROWING A GOATEE, ARE YOU?"

Felicity | 1998–2002
Keri Russell, styled by Laura LaRocca

CAROL BRADY

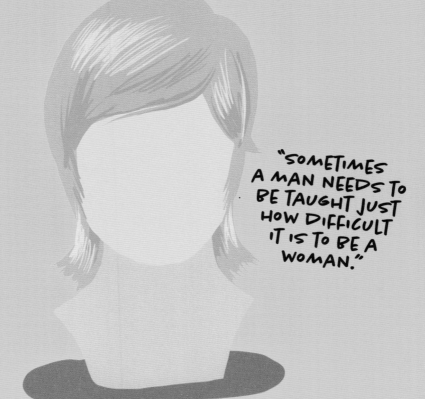

"SOMETIMES A MAN NEEDS TO BE TAUGHT JUST HOW DIFFICULT IT IS TO BE A WOMAN."

The Brady Bunch | 1969–1974
Florence Henderson, styled by Sharleen Rassi

JUDY

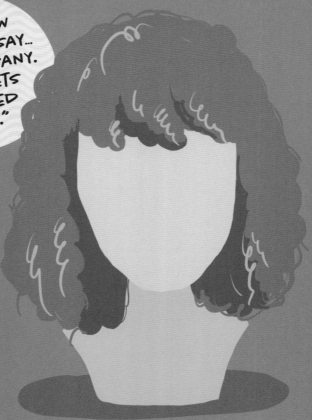

"YOU KNOW WHAT THEY SAY... TWO'S COMPANY. THREE GETS US TALKED ABOUT."

BMX Bandits (*Short Wave*, in the USA) | 1983
Nicole Kidman, styled by Willi Kenrick

BARB

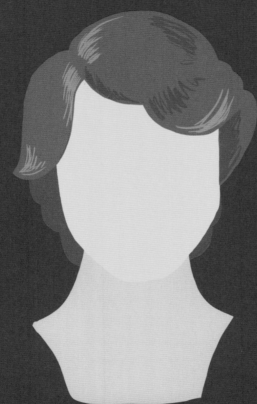

"IS THAT A NEW BRA?"

Stranger Things Season 1 | 2016
Shannon Purser, styled by Sarah Hindsgaul

37

MUSIC

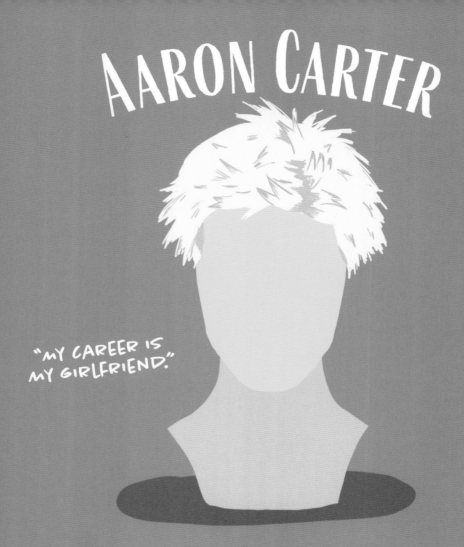

AARON CARTER

"MY CAREER IS MY GIRLFRIEND."

2000 | Biggest hit: "Aaron's Party (Come Get It)"

GWEN STEFANI

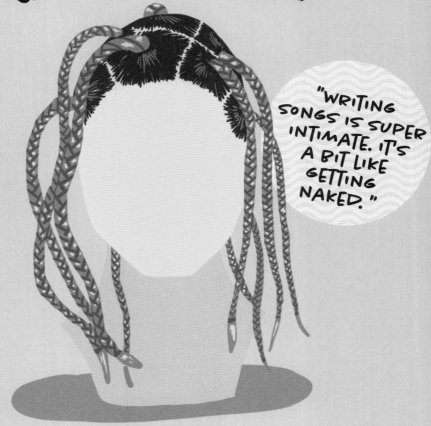

"WRITING SONGS IS SUPER INTIMATE. IT'S A BIT LIKE GETTING NAKED."

1998 | Biggest hit: "Hollaback Girl"

SINÉAD O'CONNOR

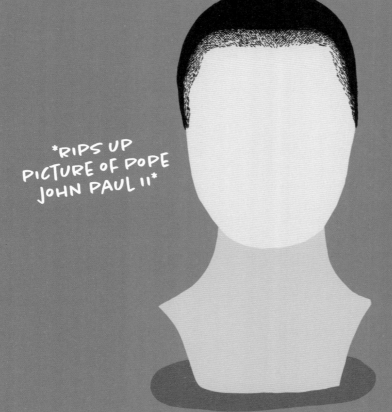

*RIPS UP
PICTURE OF POPE
JOHN PAUL II*

1987 | Biggest hit: "Nothing Compares 2 U"

BRITNEY SPEARS

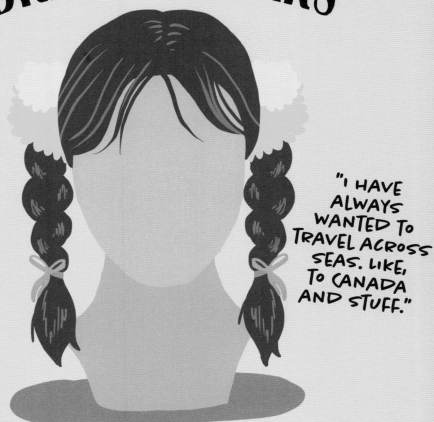

"I HAVE ALWAYS WANTED TO TRAVEL ACROSS SEAS. LIKE, TO CANADA AND STUFF."

1998 | Biggest hit: "...Baby One More Time"

ELVIS PRESLEY

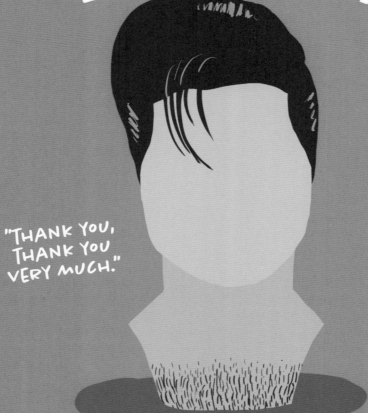

"THANK YOU, THANK YOU VERY MUCH."

1955 | Biggest hit: "Jailhouse Rock"

AMY WINEHOUSE

> "EVERY BAD SITUATION IS A BLUES SONG WAITING TO HAPPEN."

2006 | Biggest hit: "Valerie"

45

JUSTIN BIEBER

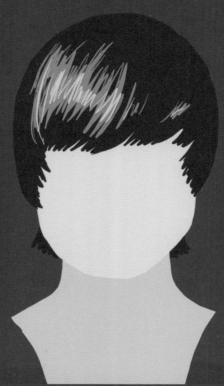

"YEAH, I'M A GREAT KISSER."

2009 | Biggest hit: "Sorry"

LADY GAGA

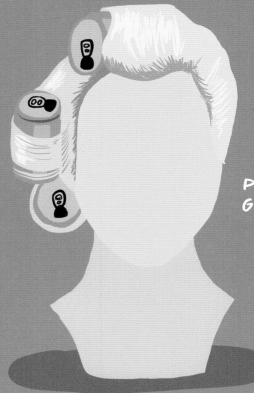

"GOD BLESS POP MUSIC, AND GOD BLESS MTV."

2009 | Biggest hit: "Poker Face"

KYLIE MINOGUE

"GAY ICONS USUALLY HAVE SOME TRAGEDY IN THEIR LIVES, BUT I'VE ONLY HAD TRAGIC HAIRCUTS AND OUTFITS."

1988 | Biggest hit: "Can't Get You Out of My Head"

BEYONCÉ

"I'M NOT BOSSY. I'M THE BOSS."

2016 | Biggest hit: "Irreplaceable"

DIANA ROSS

"IT TAKES A LONG TIME TO GET TO BE A DIVA. I MEAN, YOU GOTTA WORK AT IT."

1975 | Biggest hit: "Upside Down"

PRINCE

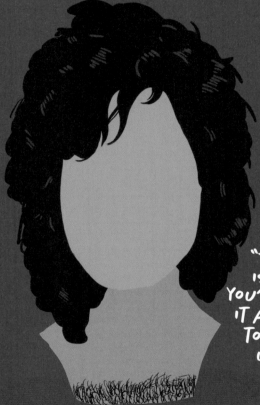

"TECHNOLOGY IS COOL, BUT YOU'VE GOT TO USE IT AS OPPOSED TO LETTING IT USE YOU."

1984 | Biggest hit: "When Doves Cry"

JUSTIN TIMBERLAKE

"IF ENTERTAINMENT YEARS WERE DOG YEARS, MAN, I'D BE LIKE GANDHI. I'D BE, LIKE, 250 YEARS OLD."

1995 | Biggest hit: "Can't Stop the Feeling!"

SALT-N-PEPA

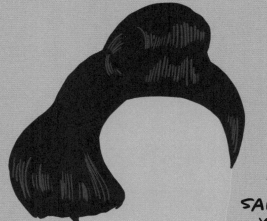

"I'VE ALWAYS SAID, IF YOU TREAT YOURSELF LIKE A QUEEN, YOU'LL ATTRACT A KING."
— PEPA

1988 | Biggest hit: "Whatta Man"

MICHAEL BOLTON

"YOU CAN'T MAKE EVERYBODY LOVE WHAT YOU DO, BUT YOU CAN KNOW HOW GREAT YOU FEEL DOING IT."

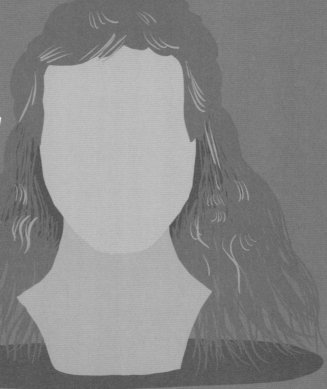

1991 | Biggest hit: "How Am I Supposed to Live Without You"

DOLLY PARTON

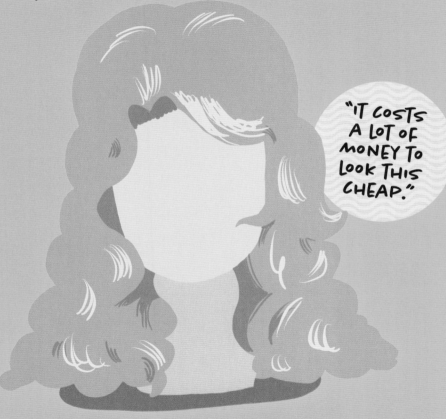

"IT COSTS A LOT OF MONEY TO LOOK THIS CHEAP."

1974 | Biggest hit: "9 to 5"

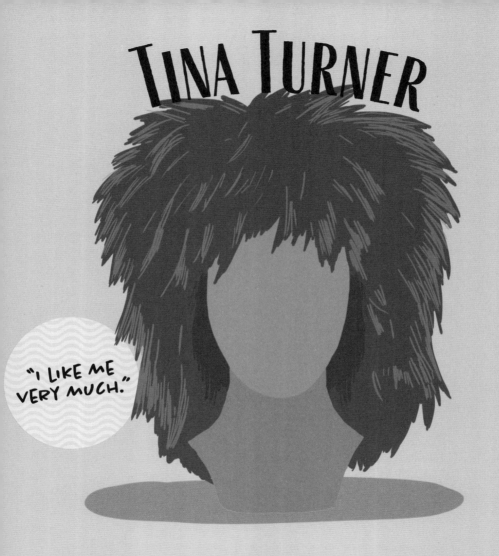

TINA TURNER

"I LIKE ME VERY MUCH."

1984 | Biggest hit: "What's Love Got to Do with It"

56

GRACE JONES

"I ONLY MOVE FORWARDS. NEVER BACKWARDS, DARLING."

1980 | Biggest hit: "La Vie En Rose"

SADE ADU

"I'M NOT SHY OR RECLUSIVE. I JUST SPEND MY TIME WITH PEOPLE RATHER THAN JOURNALISTS."

1984 | Biggest hit: "The Sweetest Taboo"

RIHANNA

"I DRINK A LOT OF COCONUT WATER. IT BALANCES OUT ALL THE OTHER TOXIC STUFF I PUT INTO MY BODY."

2010 | Biggest hit: "We Found Love"

FRANK OCEAN

"THE INTERNET MADE FAME WACK AND ANONYMITY COOL."

2016 | Biggest hit: "Thinkin Bout You"

NICKI MINAJ

"THERE IS A DIFFERENCE BETWEEN A PASSION AND A FUCKING MELTDOWN."

2012 | Biggest hit: "Super Bass"

PAUL McCARTNEY

"BEING IN THE AUDIENCE ACTUALLY LOOKS LIKE QUITE A LOT OF FUN."

1992 | Biggest (non-Beatles) hit: "Silly Love Songs"

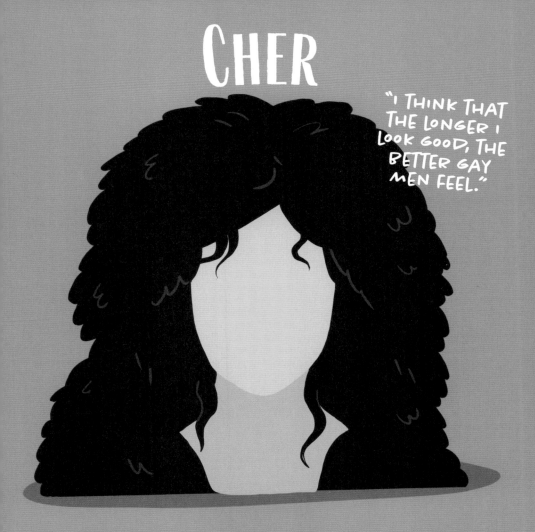

CHER

"I THINK THAT THE LONGER I LOOK GOOD, THE BETTER GAY MEN FEEL."

1989 | Biggest hit: "Believe"

CELEBRITIES

MIA FARROW

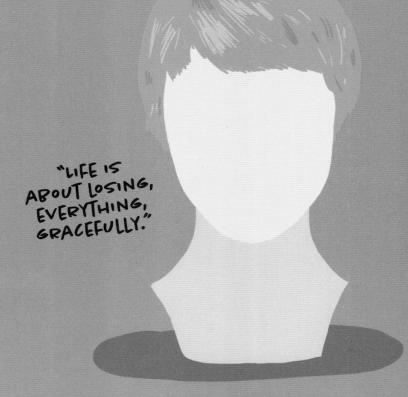

"LIFE IS ABOUT LOSING, EVERYTHING, GRACEFULLY."

1966 | Model, actor, and activist

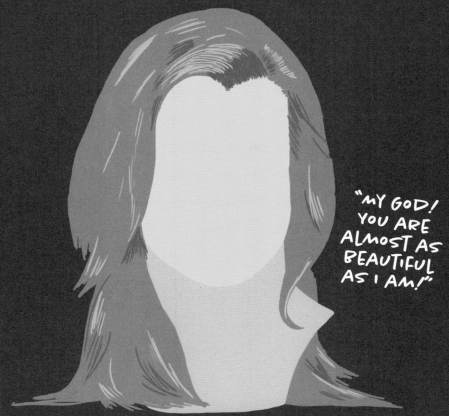

"MY GOD! YOU ARE ALMOST AS BEAUTIFUL AS I AM!"

1992 | Spokesperson for I Can't Believe It's Not Butter!

DONALD TRUMP

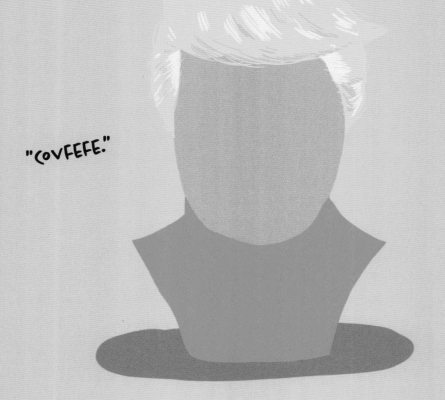

"COVFEFE."

2006 | Bewilderingly, the 45th President of the United States

MARIE ANTOINETTE

"WE HAD A BEAUTIFUL DREAM AND THAT WAS ALL."

1780 | The last Queen of France

TWIGGY

"YOU CAN'T BE A CLOTHES HANGER FOR YOUR ENTIRE LIFE."

1965 | Icon of London's Swinging Sixties

FARRAH FAWCETT

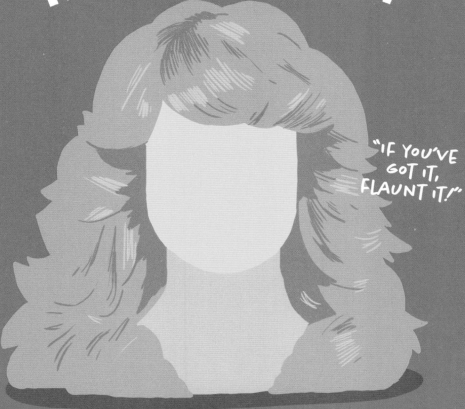

"IF YOU'VE GOT IT, FLAUNT IT!"

1973 | *Charlie's Angels* alum and model

KARL LAGERFELD

"VANITY IS THE HEALTHIEST THING IN LIFE."

1995 | Creative director of Chanel

ANNA WINTOUR

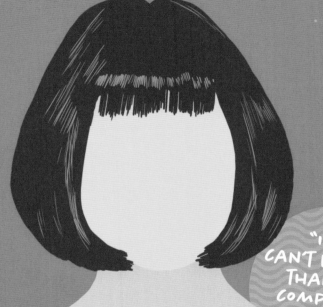

"IF YOU CAN'T BE BETTER THAN YOUR COMPETITION, JUST DRESS BETTER."

1995 | Editor-in-chief of *Vogue*

ANDY WARHOL

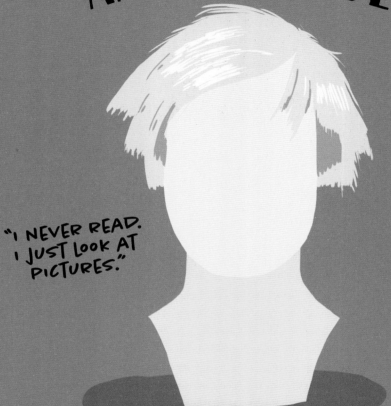

"I NEVER READ.
I JUST LOOK AT
PICTURES."

1982 | Pop art juggernaut

PATTI SMITH

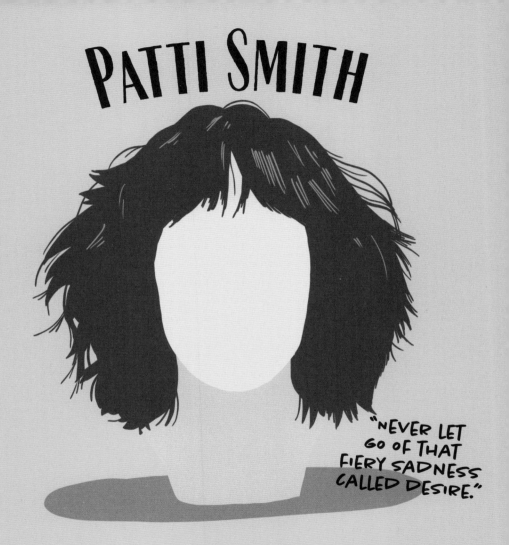

"NEVER LET GO OF THAT FIERY SADNESS CALLED DESIRE."

1975 | Poet, punk rock icon, and author

HULK HOGAN

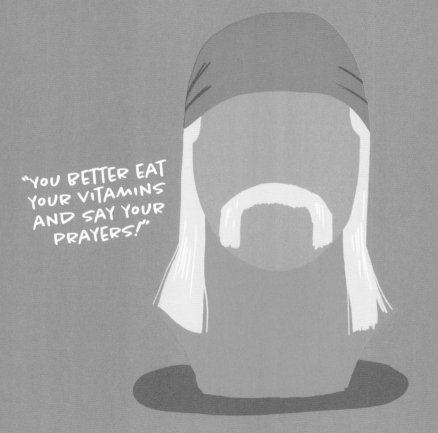

"YOU BETTER EAT YOUR VITAMINS AND SAY YOUR PRAYERS!"

1987 | Pro wrestler and TV personality

MR T

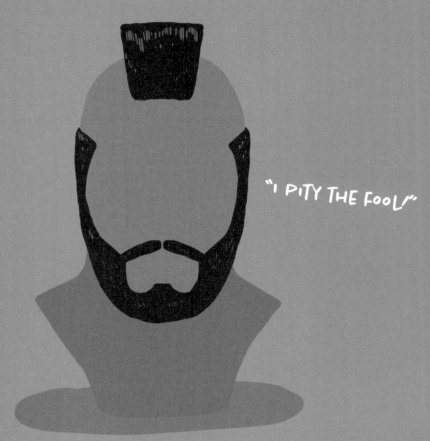

"I PITY THE FOOL"

1981 | *The A-Team* alum and TV personality

ALBERT EINSTEIN

"SCIENCE CAN FLOURISH ONLY IN AN ATMOSPHERE OF FREE SPEECH."

1940 | Theoretical physicist and Nobel Laureate

JEAN-MICHEL BASQUIAT

"I DON'T KNOW ANYBODY WHO NEEDS A CRITIC TO FIND OUT WHAT ART IS."

1986 | Street artist and social commentator

MOLLY RINGWALD

"I HAVE A REALLY LOW TOLERANCE FOR DEHYDRATION."

1985 | *The Breakfast Club* alum, author, and translator

PRINCESS DIANA

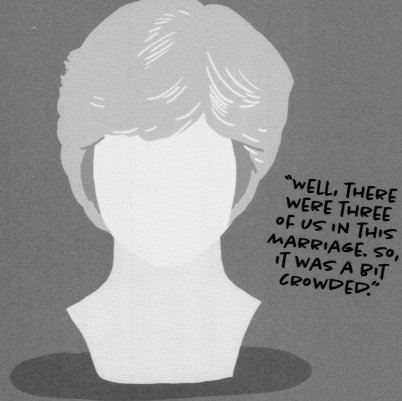

"WELL, THERE WERE THREE OF US IN THIS MARRIAGE. SO, IT WAS A BIT CROWDED."

1990 | British Royal, activist, and a *Candle in the Wind*

SOPHIA LOREN

"A WOMAN'S DRESS SHOULD BE LIKE A BARBED-WIRE FENCE: SERVING ITS PURPOSE WITHOUT OBSTRUCTING THE VIEW."

1965 | Actor and singer of the Golden Age of Hollywood

JACKIE KENNEDY

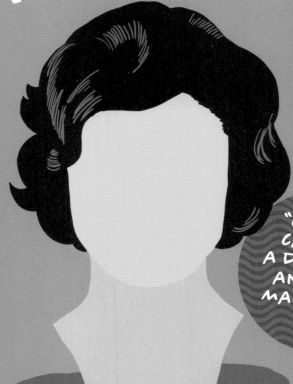

"ONE MAN CAN MAKE A DIFFERENCE AND EVERY MAN SHOULD TRY."

1961 | First (Fashionable) Lady of the Unites States

JULIA ROBERTS

"THOUGHT I WOULD JINX IT IF I WROTE A SPEECH, AND NOW I THINK I REALLY SCREWED UP."

1990 | Actor and producer of *Pretty Woman* fame

JULIA CHILD

"THE ONLY TIME TO EAT DIET FOOD IS WHILE YOU'RE WAITING FOR THE STEAK TO COOK."

1960 | Author and TV personality, introduced French cuisine to America

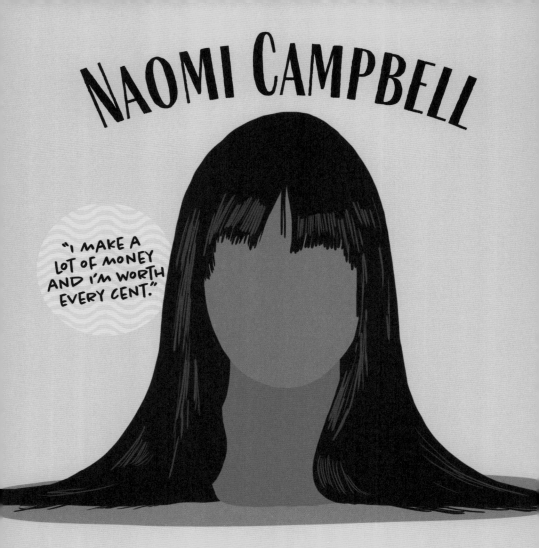

NAOMI CAMPBELL

"I MAKE A LOT OF MONEY AND I'M WORTH EVERY CENT."

1996 | International supermodel

VICTORIA BECKHAM

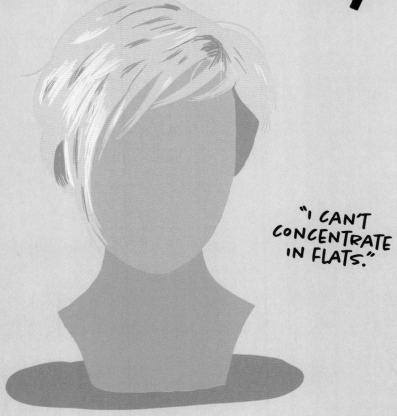

"I CAN'T CONCENTRATE IN FLATS."

2007 | Spice Girl, fashion designer, and entrepreneur

NELSON MANDELA

"IT ALWAYS
SEEMS
IMPOSSIBLE
UNTIL IT'S
DONE."

1985 | Politician and revolutionary

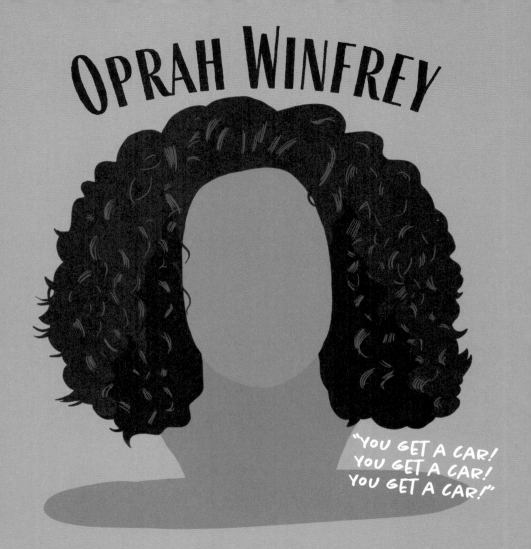

ANIMATED
ICONS

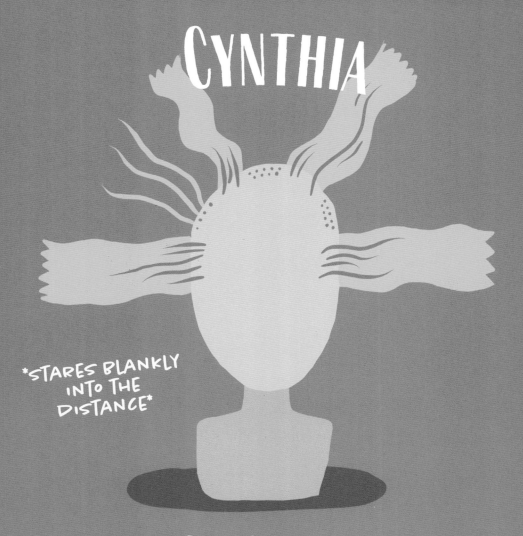

CYNTHIA

STARES BLANKLY INTO THE DISTANCE

Rugrats | 1991–2004
Created by Gábor Csupó, Arlene Klasky, and Paul Germain

SELMA

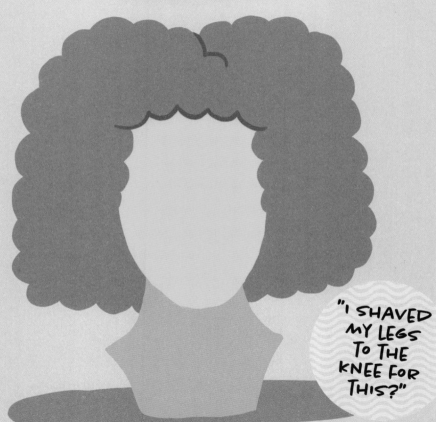

"I SHAVED MY LEGS TO THE KNEE FOR THIS?"

The Simpsons | 1989–present
Created by Matt Groening

WILMA

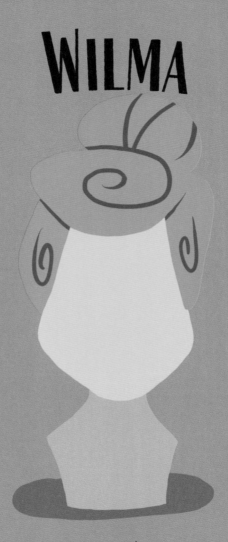

"FRED!"

The Flintstones | 1960–1966
Created by William Hanna and Joseph Barbera

DARIA

"I DON'T LIKE TO SMILE UNLESS I HAVE A REASON."

Daria | 1997–2002
Created by Glenn Eichler and Susie Lewis Lynn

95

FA MULAN

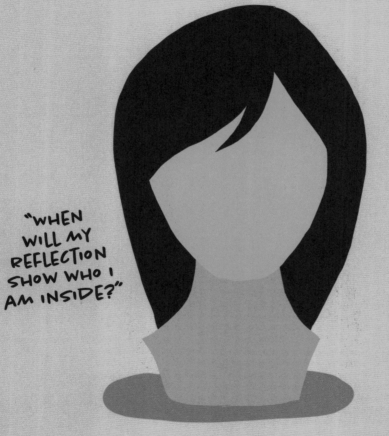

"WHEN WILL MY REFLECTION SHOW WHO I AM INSIDE?"

Mulan | 1998
Created by Tony Bancroft and Barry Cook

URSULA

"LIFE'S FULL OF TOUGH CHOICES, INNIT?"

The Little Mermaid | 1989
Created by Ron Clements and John Musker

GERALD

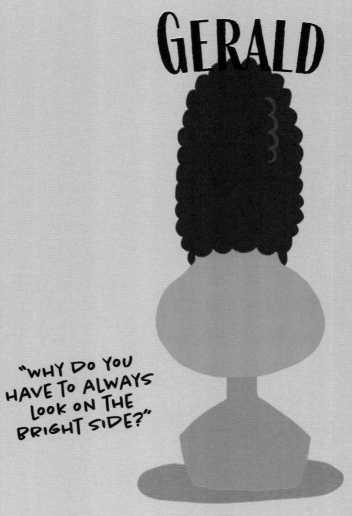

"WHY DO YOU HAVE TO ALWAYS LOOK ON THE BRIGHT SIDE?"

Hey Arnold! | 1996–2004
Created by Craig Bartlett

CRUELLA DE VIL

"DARLING, LOOKING GOOD IS BETTER THAN BEING GOOD."

101 Dalmatians | 1961
Created by Dodie Smith

VELMA

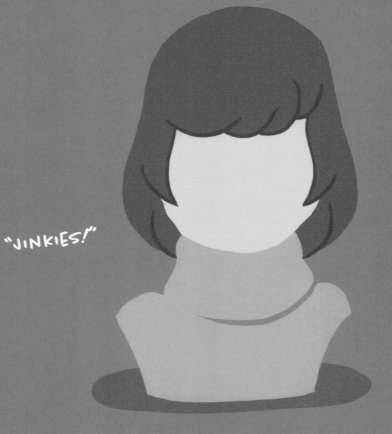

"JINKIES!"

Scooby-Doo, Where Are You? | 1969–1970
Created by Joe Ruby and Ken Spears

SAILOR MOON

"THE TOUGH EXPERIENCES IN LIFE ARE WHAT MAKE US GIRLS PRETTIER."

Sailor Moon | 1991–1997
Created by Naoko Takeuchi

JEM

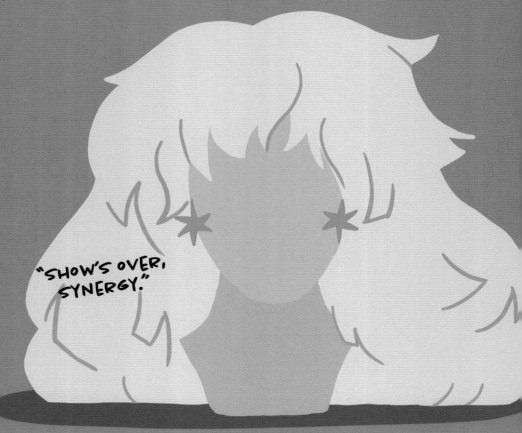

Jem and the Holograms | 1985–1988
Created by Christy Marx

HE-MAN

"I HAVE THE POWER!"

He-Man and the Masters of the Universe | 1983–1985
Created (arguably) by Roger Sweet

LARA CROFT

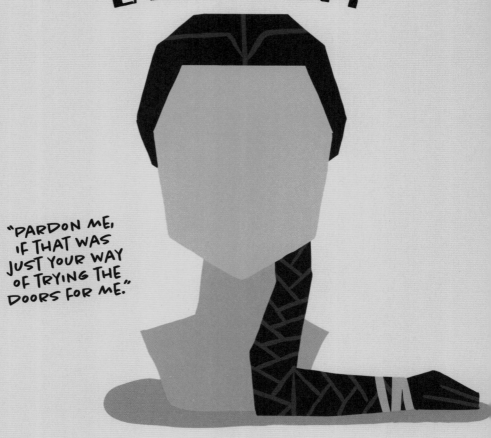

"PARDON ME,
IF THAT WAS
JUST YOUR WAY
OF TRYING THE
DOORS FOR ME."

Tomb Raider | 1996
Created by Toby Guard

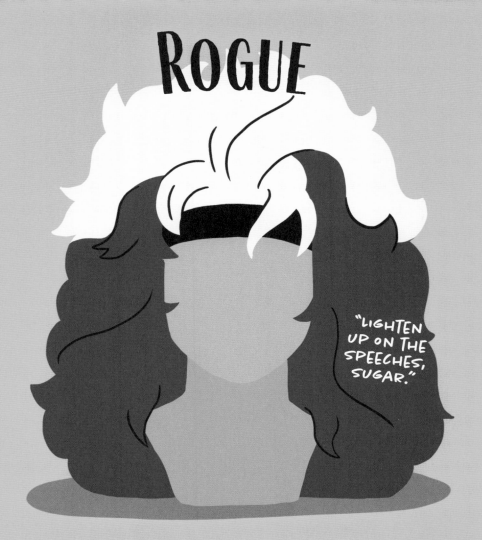

ROGUE

"LIGHTEN UP ON THE SPEECHES, SUGAR."

X-men: *The Animated Series* | 1992–1997
Created by Stan Lee and Jack Kirby

CLOUD

"NOT INTERESTED. (IT'S NOT MY PROBLEM.)"

Final Fantasy VII | 1997
Created by Tetsuya Nomura

LINK

"GAAAAH!"

The Legend of Zelda | 1986
Created by Shigeru Miyamoto and Takashi Tezuka

ASTRO BOY

"THIS IS IT. THIS IS WHAT I WAS CREATED FOR. THIS IS MY DESTINY."

Astro Boy (Mighty Atom, in Japan) | 1952
Created by Osamu Tezuka

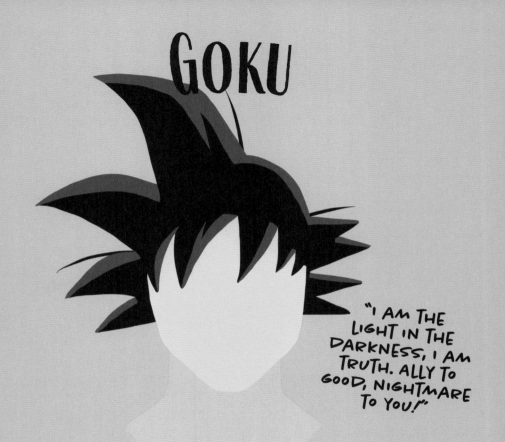

GOKU

"I AM THE LIGHT IN THE DARKNESS, I AM TRUTH. ALLY TO GOOD, NIGHTMARE TO YOU!"

Dragon Ball | 1984–1995
Created by Akira Toriyama

PRINCESS PEACH

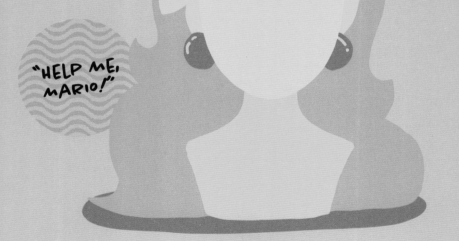

"HELP ME, MARIO!"

Super Mario Bros. | 1985
Created by Shigeru Miyamoto and Yōichi Kotabe

JIGGLYPUFF

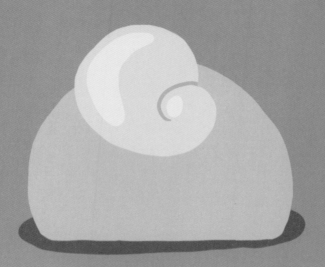

"JIIIGGGLLLYYYPPUUUUUFFFF JIIGGLLLYYYYYYYYYYPUFF"

Pokémon Red and *Blue* | 1996
Created by Ken Sugimori and Satoshi Tajiri

Published in 2020 by Smith Street Books
Melbourne | Australia
smithstreetbooks.com

ISBN: 978-1-925811-48-3

Publisher: Paul McNally
Project editor: Patrick Boyle
Designer: Andy Warren
Design layout: Heather Menzies, Studio31 Graphics

Printed & bound in China by C&C Offset Printing Co., Ltd.

Book 128
10 9 8 7 6 5 4 3 2 1